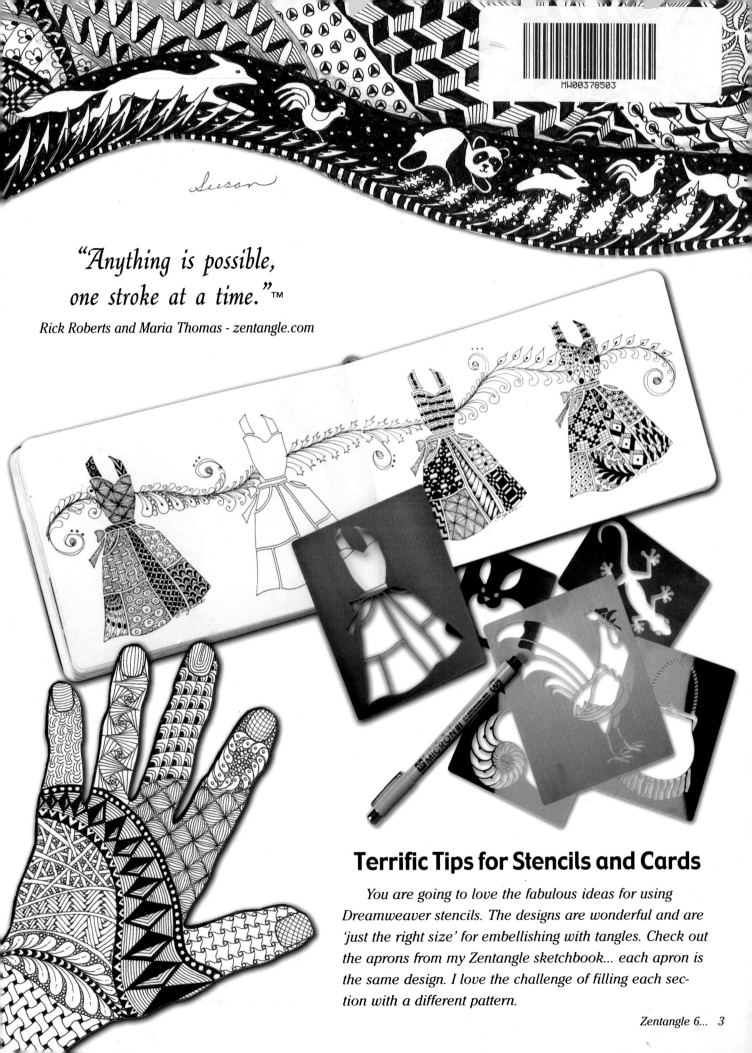

Susan

> *"Anything is possible,
> one stroke at a time."*™
>
> *Rick Roberts and Maria Thomas - zentangle.com*

Terrific Tips for Stencils and Cards

You are going to love the fabulous ideas for using Dreamweaver stencils. The designs are wonderful and are 'just the right size' for embellishing with tangles. Check out the aprons from my Zentangle sketchbook... each apron is the same design. I love the challenge of filling each section with a different pattern.

Classic Zentangle...

A very simple ritual is part of every classic Zentangle.

1. Make a dot in each corner of your paper tile with a pencil. Connect the dots to form a border.

2. Draw guideline "strings" with the pencil. The shape can be a zig-zag, swirl, X, circle or just about anything that divides the area into sections. It represents the "golden thread" that connects all the patterns and events that run through life. The strings will not be erased but will disappear.

3. Use a black pen to draw Tangle patterns into each section formed by the "string".

4. Rotate the paper tile as you fill each section with a pattern.

What you'll need to get started...

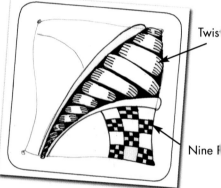

Zentangle's 3¹/₂" x 3¹/₂" die-cut 'tile' is suggested

a pencil

a black permanent marker - a Micron 01 Pigma pigment ink pen by *Sakura* is suggested

How to Get Started...

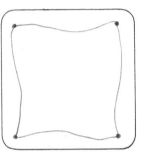
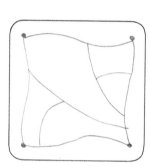

Twist

Nine P

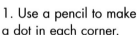

1. Use a pencil to make a dot in each corner.

2. Connect the dots with the pencil.

3. Draw a 'string' with the pencil as a guideline.
 Try a Z zig-zag, a ∂ loop, an X 'X', or a swirl.

4. Switch to a black pen and draw a tangle pattern in each section.

 When you cross a line, change the pattern. It is OK to leave some sections blank.

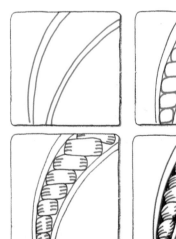

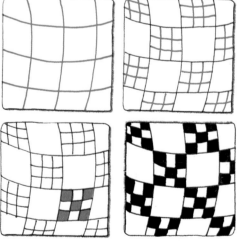

Each Tangle is a unique artistic design and there are hundreds of variations. Start with basic patterns, then create your own. With Zentangle, no eraser is needed. Just as in life, we cannot erase events and mistakes. Instead, we must build upon them and make improvements from any event.

Life is a building process. All events and experiences are incorporated into our learning process and into life patterns.

Twister

1. Draw 2 sets of curved lines, closer together at the bottom than the top.
2. Fill the interior space with ovals.
3. Add 3 dashes to each side of ovals.
4. Color the background black.

Nine Patch

1. Draw a grid - curved lines are OK.
2. In alternate spaces, draw a checkerboard pattern of 9 squares.
3. Fill in the corner squares and center of each checkerboard.

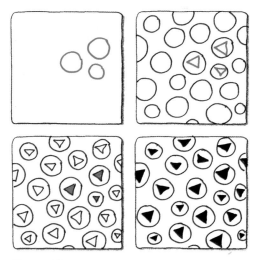
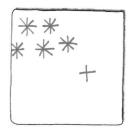

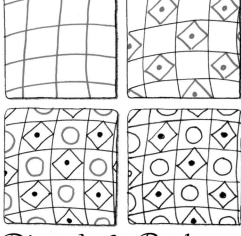

Satellites

1. Draw circles at random.
2. Draw a triangle in each circle.
3. Color each triangle black.

Starry Night

1. Draw a plus sign.
2. Draw 2 diagonal lines through the center.

Diamonds & Pearls

1. Draw a grid - curved lines are OK.
2. Draw a diamond with a dot in the middle in alternating spaces.
3. In each empty space, draw a circle.

Practice a new tangle pattern and draw a new tile design every day.

Optional...
Shading Your Zentangle

Shading adds a touch of dimension.
1. Use the side of your pencil to gently color areas and details gray.
2. Rub the pencil areas with a 'paper stump' to blend the gray.

Note: Use shading sparingly. Be sure to leave white sections white.

Where to Add Shading...

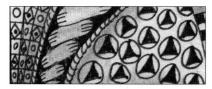

Around the edge of Twister

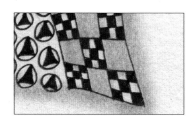

Along the edges of Nine Patch

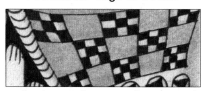

In background spaces of Nine Patch

On one side of Diamonds & Pearls

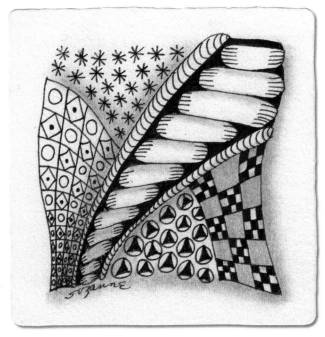

Use a pencil to add shading and use a 'paper stump' to rub the pencil areas to smudge, soften and blend the gray shadows.

Add shading along the right edge and the bottom of your finished shape. Make the shading about 1/8" wide, to "raise" tangles off the page.

A true 'Classic Zentangle' is created on Zentangle's custom die-cut, 3$^{1}/_{2}$" square 'tile' of archival print-making paper, using a soft graphite pencil to create your string and Sakura's black 01 Pigma Micron pen to create your tangles and to sign your Zentangle.

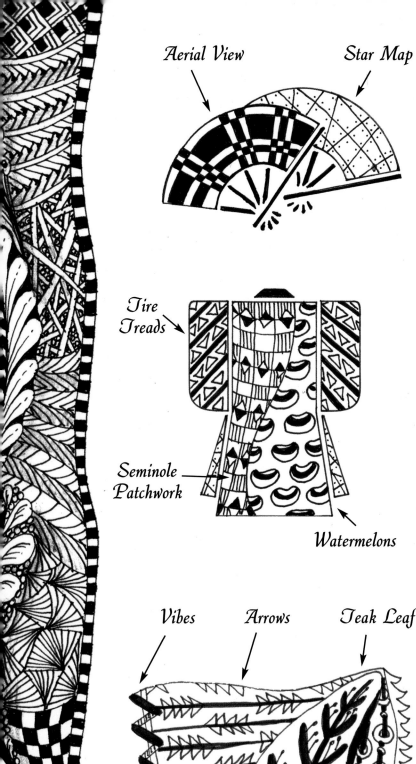

Aerial View

Star Map

Tire Treads

Seminole Patchwork

Watermelons

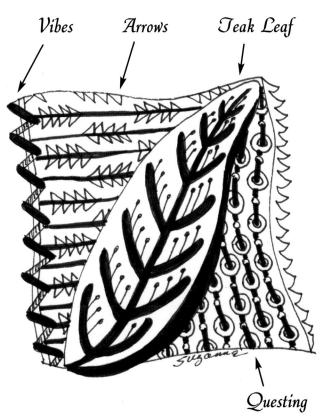

Vibes

Arrows

Teak Leaf

Questing

suzanne

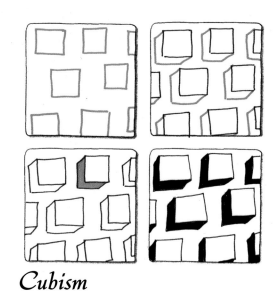

Cubism

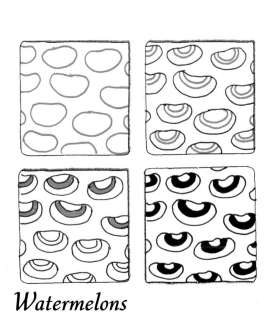

Watermelons

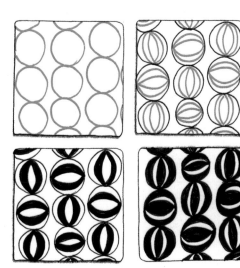

Melon

Variation

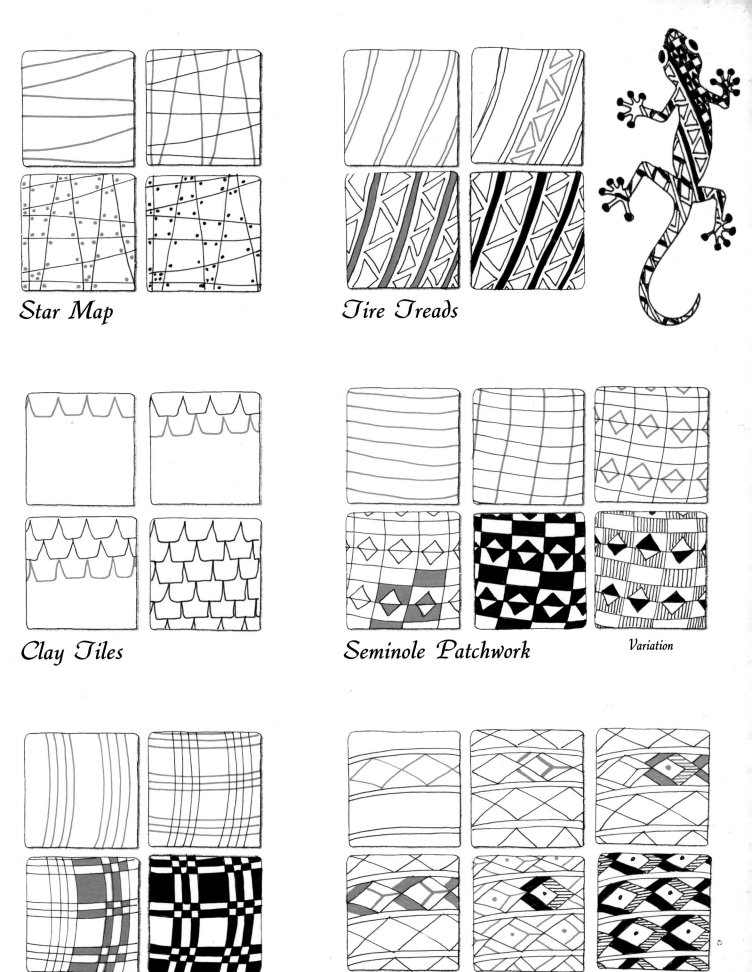

Star Map

Tire Treads

Clay Tiles

Seminole Patchwork

Variation

Aerial View

Fish

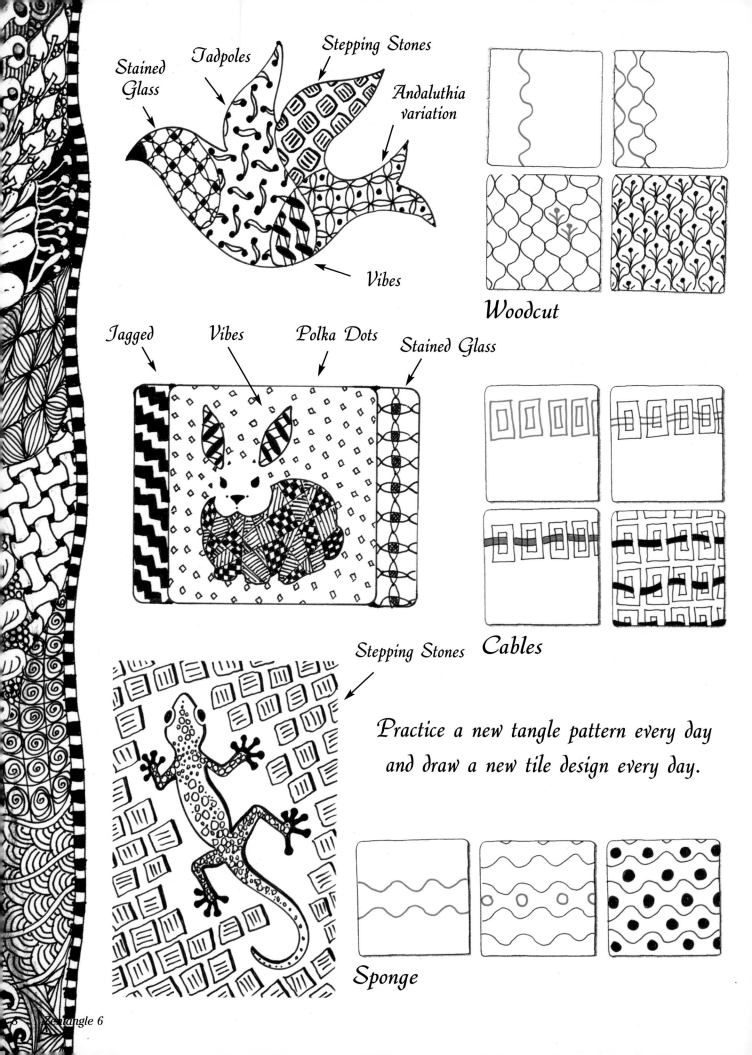

Stained Glass

Tadpoles

Stepping Stones

Andaluthia variation

Vibes

Woodcut

Jagged

Vibes

Polka Dots

Stained Glass

Cables

Stepping Stones

Practice a new tangle pattern every day
and draw a new tile design every day.

Sponge

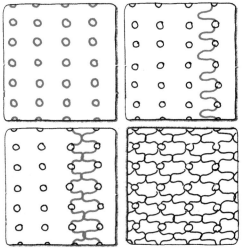

Beaded Curtain

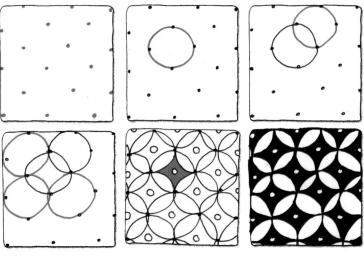

Andaluthia

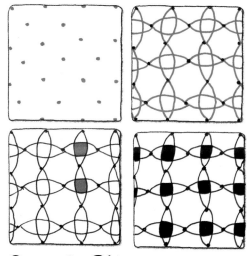

Stained Glass

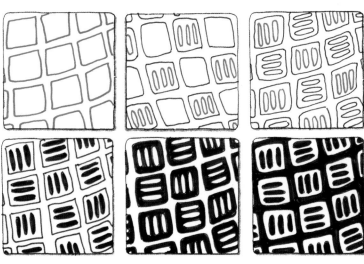

Stepping Stones *Variation* *Variation*

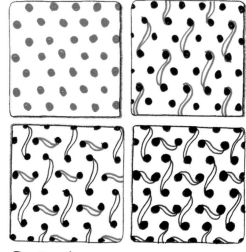

Tadpoles

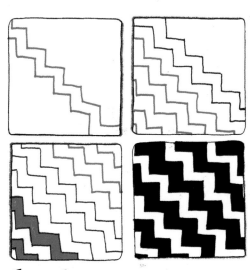

Jagged

Questing

Bristles

Nine Patch variation

Vibes

Sine Waves

Seminole Patchwork

Sea Weed
(from the Zentangle 2 book)

Suzanne

Arrow Leaf

Jagged

Suzanne

Sine Waves

Questing

Chainmaille

Cedar Leaf

Use a *Sakura* white Gelly Roll pen on a black Zentangle tile or ATC.

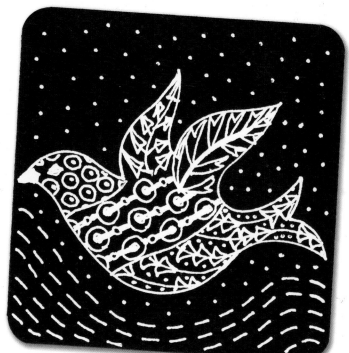

TILE
Zentangle Tile

 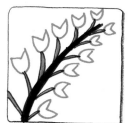 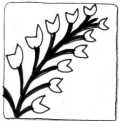

Arrow Leaf

Bluebells

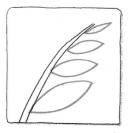 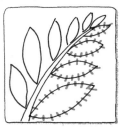 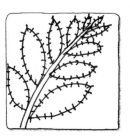

Cactus

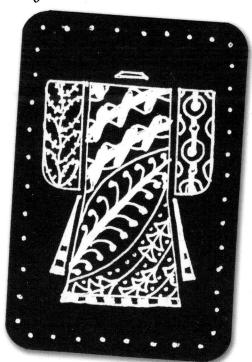

ATCs
Artist Trading Card

 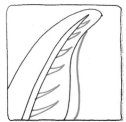 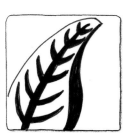

Teak Leaf

 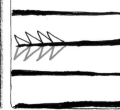

Arrows

Cream Puffs

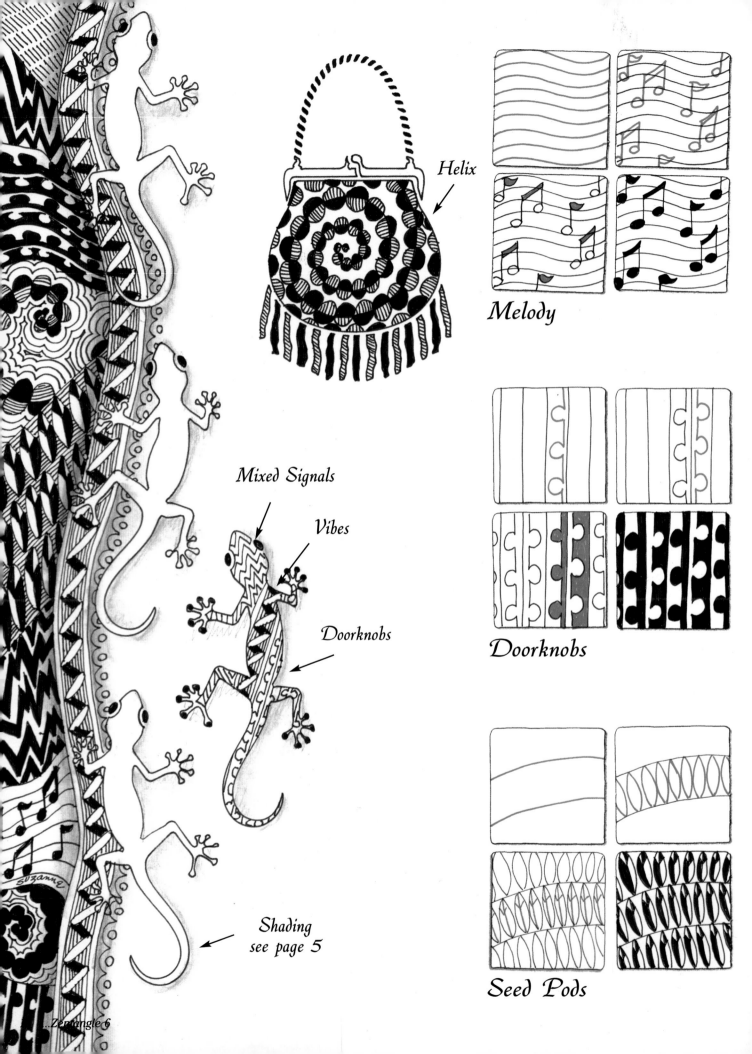

Helix

Melody

Mixed Signals

Vibes

Doorknobs

Doorknobs

Shading
see page 5

Seed Pods

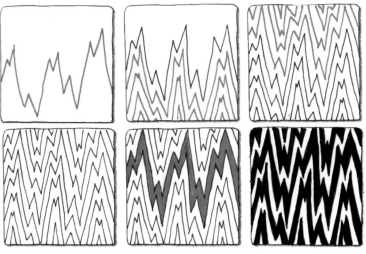

Mixed Signals

Bristles

Hair

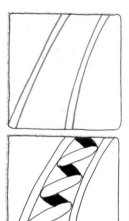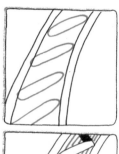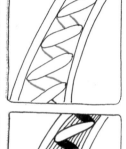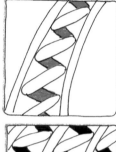

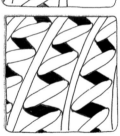

Vibes

Variation

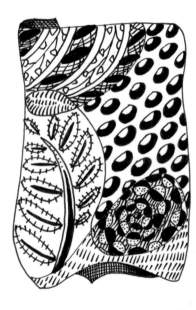

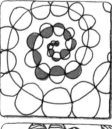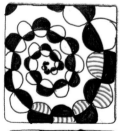

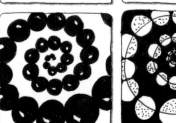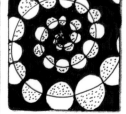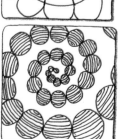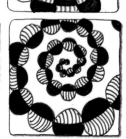

Helix

Variation *Variation* *Variation*

by Margie Whittington
mwhittingtonart.blogspot.com

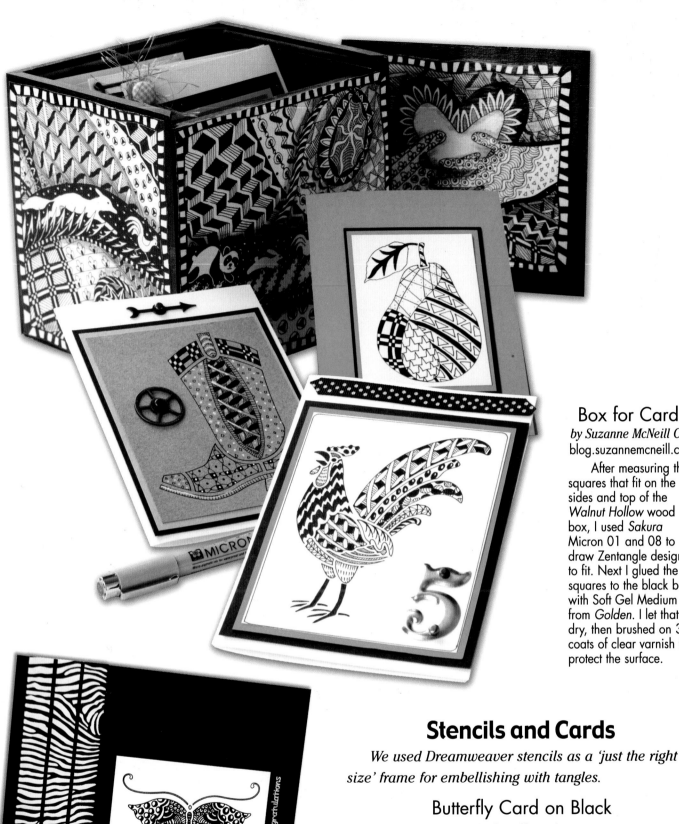

Box for Cards
by Suzanne McNeill CZT
blog.suzannemcneill.com

After measuring the squares that fit on the sides and top of the *Walnut Hollow* wood box, I used *Sakura* Micron 01 and 08 to draw Zentangle designs to fit. Next I glued the squares to the black box with Soft Gel Medium from *Golden*. I let that dry, then brushed on 3 coats of clear varnish to protect the surface.

Stencils and Cards

We used Dreamweaver stencils as a 'just the right size' frame for embellishing with tangles.

Butterfly Card on Black
by Pam Hornschu
1pamperedstamper.blogspot.com

I used *Dreamweaver* Embossing Paste and a stencil to make the animal print on the left of the black card.

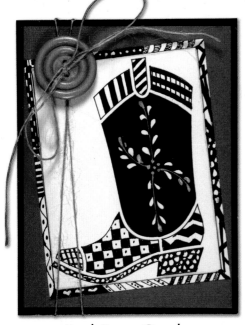

Red Boot Card
by Georgia Sommers, Castro Valley, CA
sommrstamping.blogspot.com

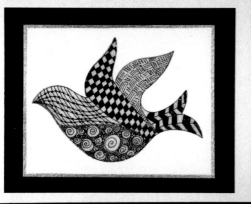

Bird Card
by Kristi Parker Van Doren, Springfield, MO
kristiscreativecafe.blogspot.com

After drawing the Zentangle, I applied
Dreamweaver Transluscent Embossing Paste and
sprinkled the wet paste with transparent glitter.

Decorative Cards
with Stencil Shapes
Drawings by Margie Whittington
Cards by Donna MJ Kinsey
mwhittingtonart.blogspot.com

I used shapes from *Dreamweaver* stencils
and *Sakura* Micron 01 and 08 to draw
Zentangle designs on white and gray Mi-Tientes
paper from *Canson*.

For the designs on gray paper I highlighted
areas with a white *Prismacolor* pencil.

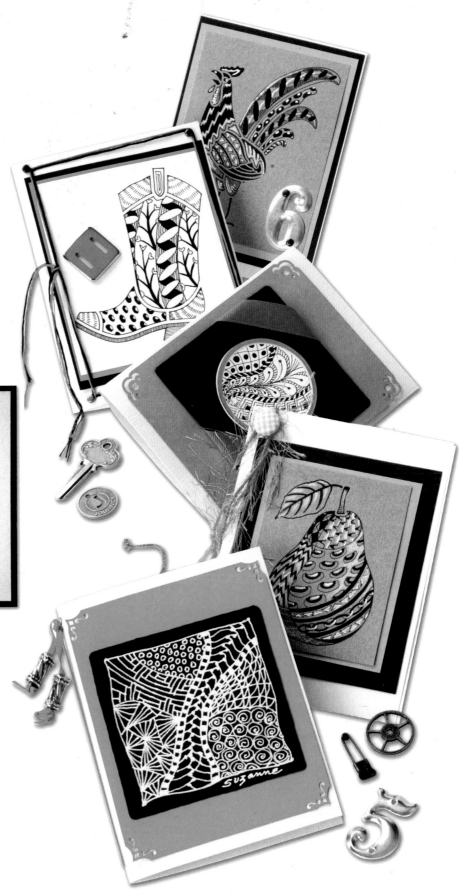

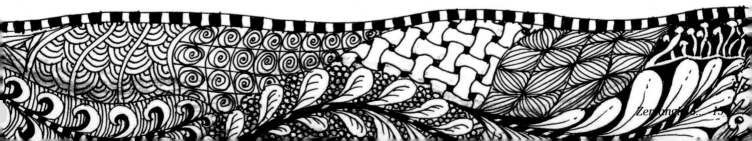

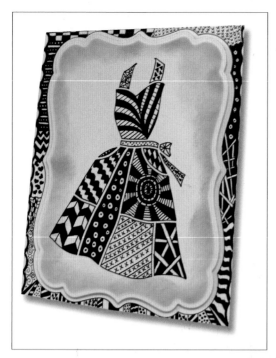

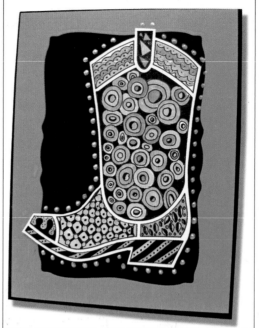

Apron Card and Boot Card

by Wendy Jordan
papertherapy-
wendy.blogspot.com

"I am a Design Team member for Lynell Harlow with *Dreamweaver Stencils*. After being introduced to Zentangle, I knew this was a technique I had to try. I love that I can bring my stencils to life with such movement and fun with Zentangling."

I use *Copic* Multiliners - sizes .03 thru .5, *Sakura* Micron Pens - sizes .005 thru .1 and *Letraset* Fine Line Drawing Pens - sizes .3 thru .7.

Stencils and Cards

Zentangle brings a fun, new concept to stencils. Draw the entire tangle design in black and white or add color and enjoy the creative process.

No two are ever alike!

Use Dreamweaver stencils as a 'just the right size' frame for embellishing with tangles.

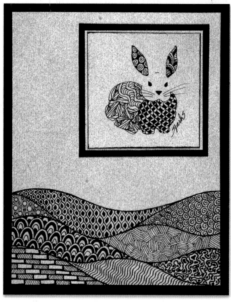

Bunny Card

Bunny by Suzanne McNeill CZT
Rolling Hills by Wayne Harlow
dreamweaverstencils.blogspot.com

I drew tangles inside the bunny stencil from *Dreamweaver Stencils*. Wayne added the tangles inside of a landscape created with wavy lines.

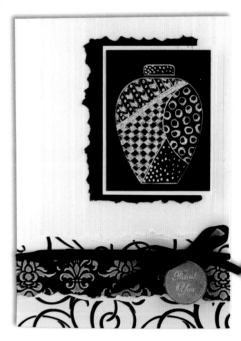

Vase Card

by Pam Hornschu
1pamperedstamper.blogspot.com
Use a white Gelly Roll pen on black paper.

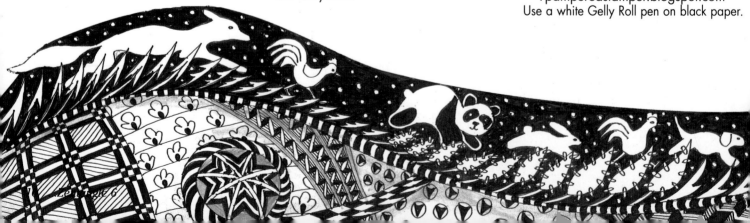

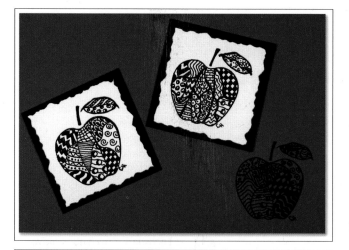

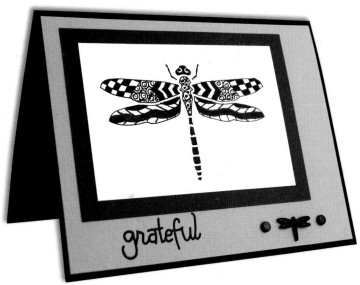

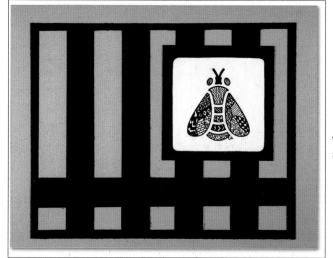

Dragonfly Card
by Pam Hornschu
1pamperedstamper.blogspot.com
"Working with *Dreamweaver* Stencils and Zentangle is a fabulous way to think outside the box while staying inside the box... or whatever stencil shape!"

Apples Card and Bee Card

by Louise Healy, Batavia, IL
artfullyarticulate.blogspot.com

I use black *Sakura* Micron Pens - sizes 005 thru 01.

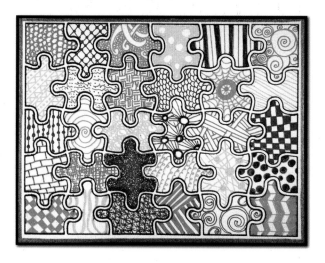

Pear Card and Puzzle Card

by Kristi Parker Van Doren
Springfield, MO
kristiscreativecafe.
blogspot.com

I use black *Sakura* Micron Pens - sizes 005 thru 01. For the colors, I use Staedtler pens.

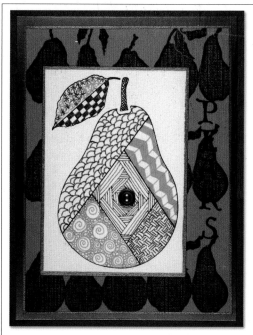

Twister
page 4

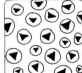
Nine Patch
page 4

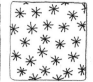
Satellites
page 5

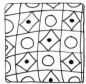
Starry Night
page 5

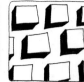
Diamonds &
Pearls
page 5

Cubism
page 6

Watermelons
page 6

Melon
page 6

Star Map
page 7

Tire Treads
page 7

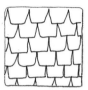
Clay Tiles
page 7

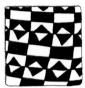
Seminole
Patchwork
page 7

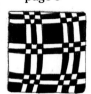
Aerial Views
page 7

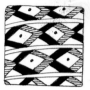
Fish
page 7

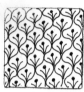
Woodcut
page 8

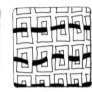
Cables
page 8

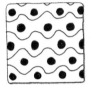
Sponge
page 8

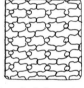
Beaded Curtain
page 9

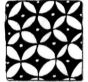
Andaluthia
page 9

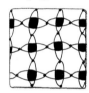
Stained Glass
page 9

Stepping Stones
page 9

Tadpoles
page 9

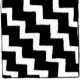
Jagged
page 9

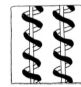
Sine Waves
page 10

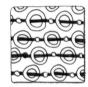
Questing
page 10

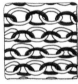
chainmaille
page 10

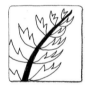
Cedar Leaf
page 11

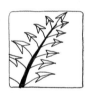
Arrow Leaf
page 11

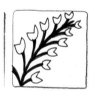
Bluebells
page 11

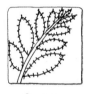
Cactus
page 11

Teak Leaf
page 11

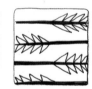
Arrows
page 11

Cream Puffs
page 11

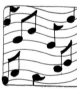
Melody
page 12

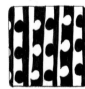
Door Knobs
page 12

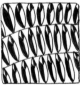
Seed Pods
page 12

Bristles & Hair
page 13

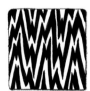
Mixed Signals
page 13

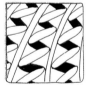
Vibes
page 13

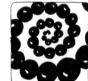
Helix
page 13

*original Zentangle design

Suzanne McNeill

Suzanne is often known as "the Trendsetter" of arts and crafts. Dedicated to hands-on creativity, she constantly tests, experiments and invents something new and fun.

Suzanne is the woman behind **Design Originals**, a publishing company dedicated to all things fun and creative. She is a designer, artist, columnist, TV personality, publisher, art instructor, author and lover of everything hands-on.

Visit Suzanne at **blog.suzannemcneill.com** to see events, books and a 'Zentangle of the Week'.

MANY THANKS to my staff for their cheerful help and wonderful ideas!
Kathy Mason • Kristy Krouse • Janet Long • Donna M.J. Kinsey
and a special Thank You to Margie Whittington

ZENTANGLE® -
You'll find wonderful resources, a list of certified teachers and workshops, a fabulous gallery of inspiring projects, kits, supplies, ATCs and tiles.
ZENTANGLE - www.zentangle.com

SUPPLIERS - Most stores carry an excellent assortment of supplies. If you need something special, ask your local store to contact the following companies.
STENCILS
 DREAMWEAVER - www.dreamweaverstencils.com
INK PENS
 SAKURA - MICRON PENS - www.sakuraofamerica.com
 SAKURA - GELLY ROLL PENS - www.sakuraofamerica.com
 LETRASET - www.letraset.com
COLOR MARKERS
 COPIC - www.copicmarker.com
STAMPS
 STAMPAFE - www.stampafe.com
WOOD BOX for CARDS
 WALNUT HOLLOW - www.walnuthollow.com